The Lost Cartoons Vol 4

In this book you will see newer cartoons from 1996-2010.

Enjoy.

P. 26

P.3

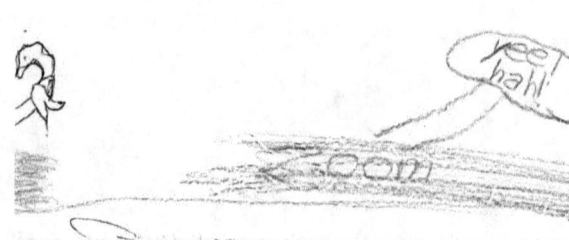

p.8

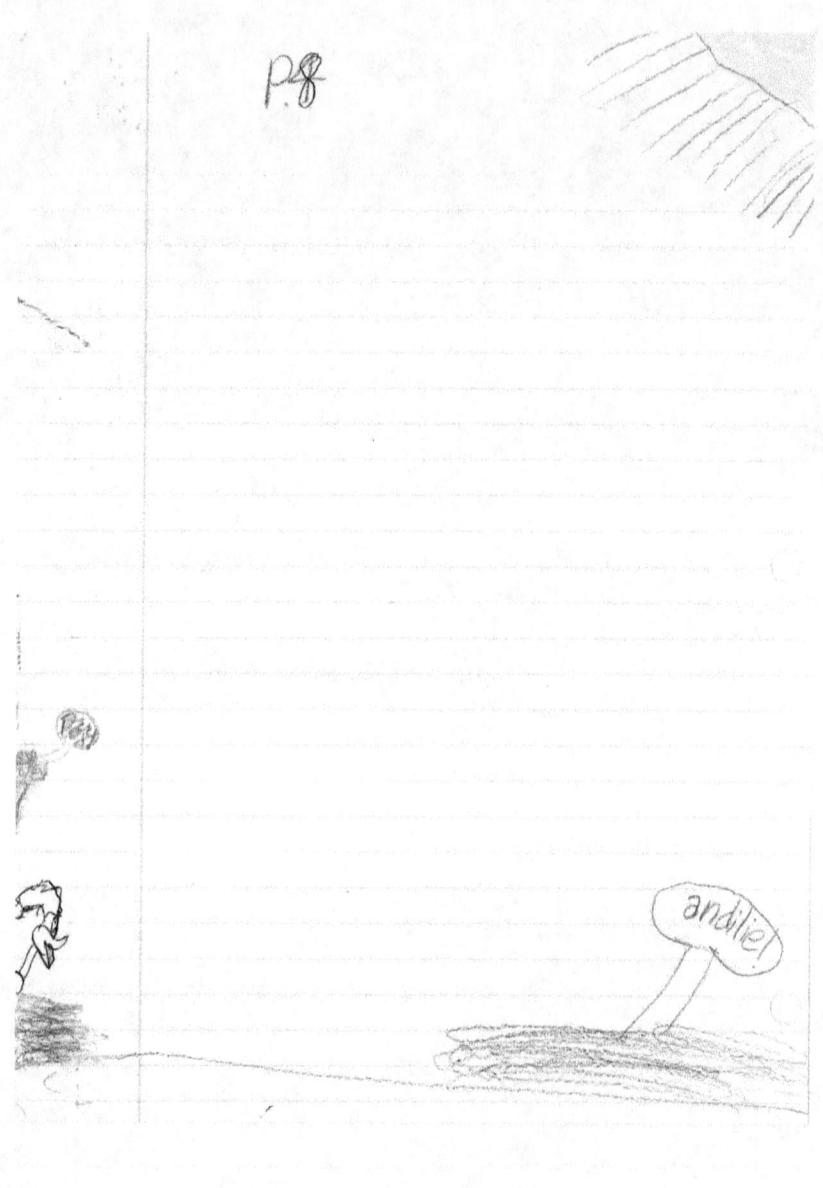

P.9

12 sec later

P.10

P. 77

Beep!

p 18
9-25-09

Bleh!

Beep!

p 73

16

13

9-25-09
p217

p 78 22

p #23

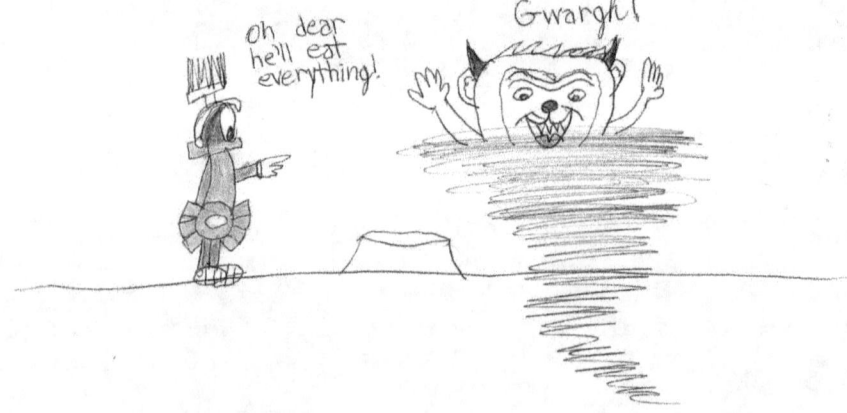

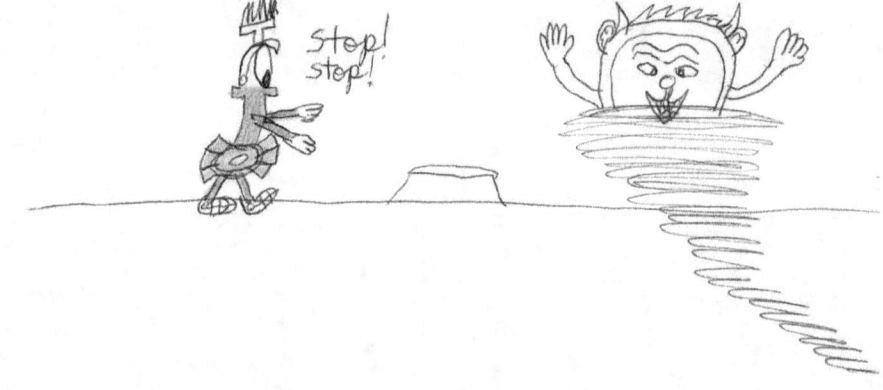

28

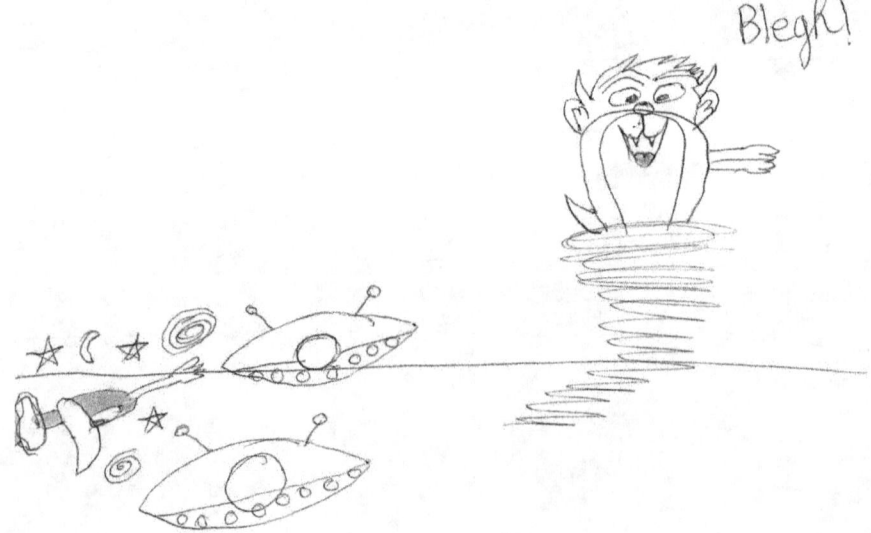

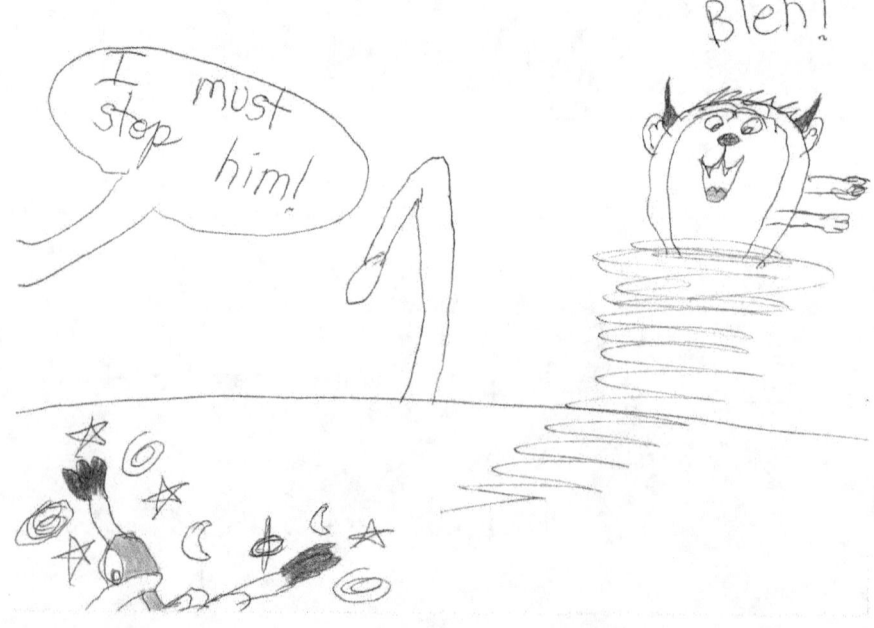

made approximately in 4-5 1996

Page 31

Outer Space and Bunnys Too

Staring for the very first

P.32 10¾ seconds later

ime is...
oney Bunny

P. 33
$1\frac{1}{2}$ seconds later

P.34

P. 35

P. 36 later 10 seconds

B37.

P.38

P.39

20 seconds Later

page 40

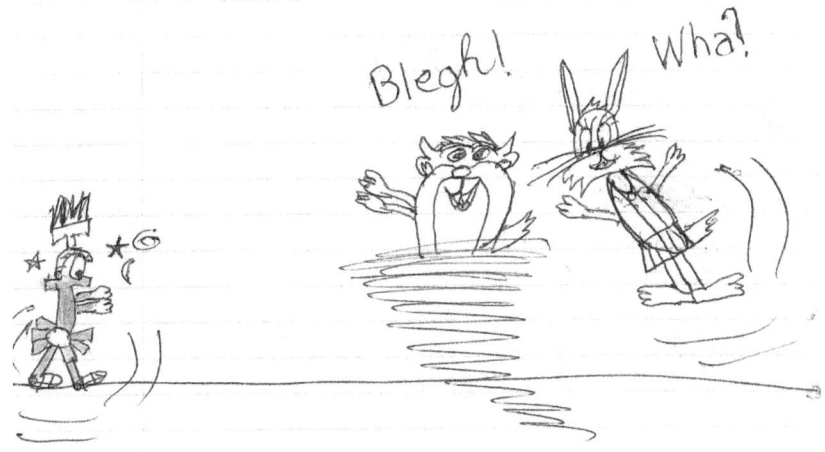

P.410

40 sec Later

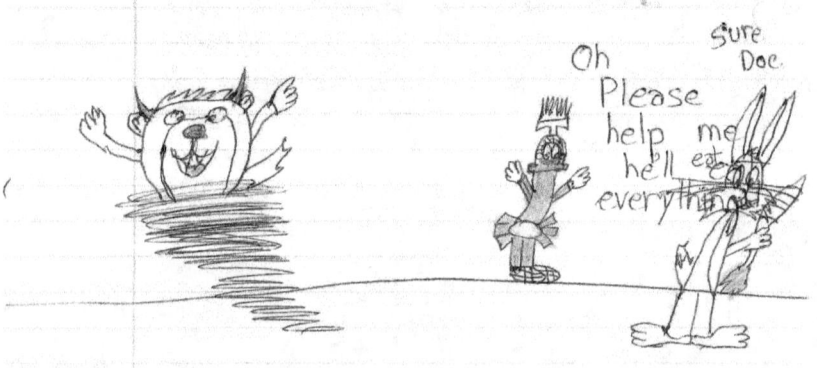

Later...

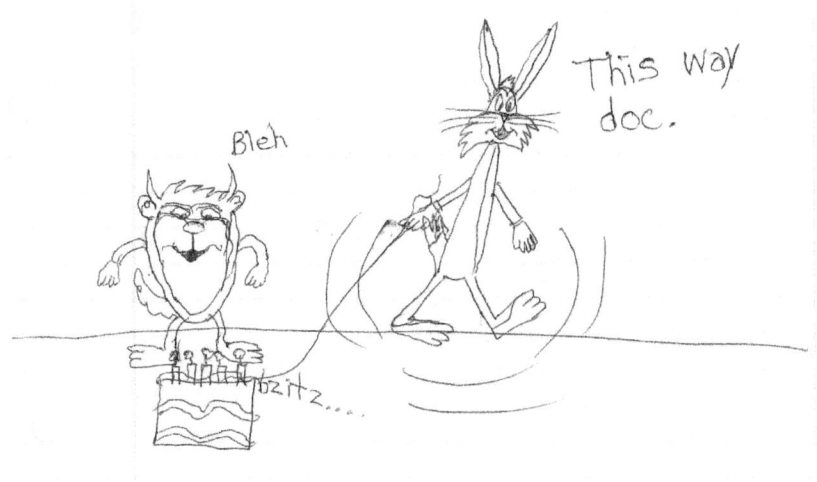

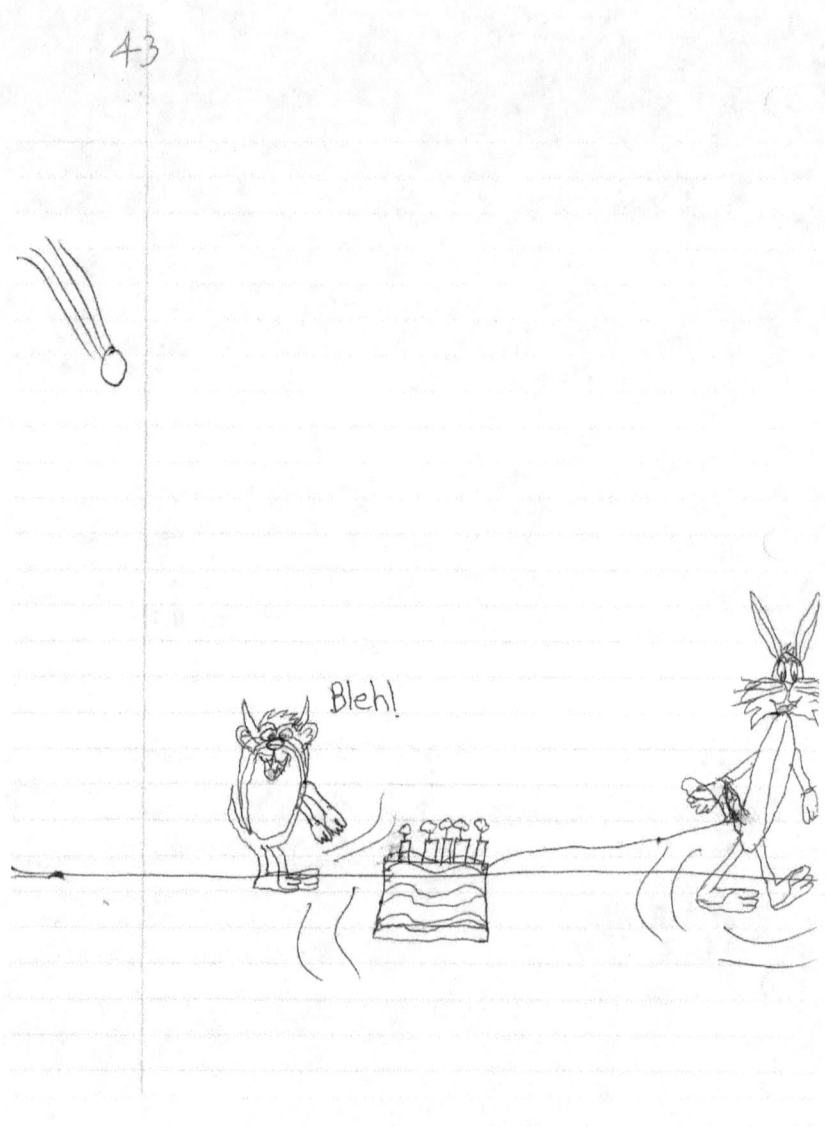

44

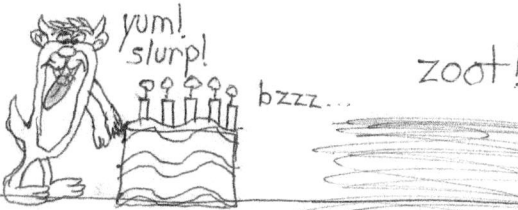

45

46

47

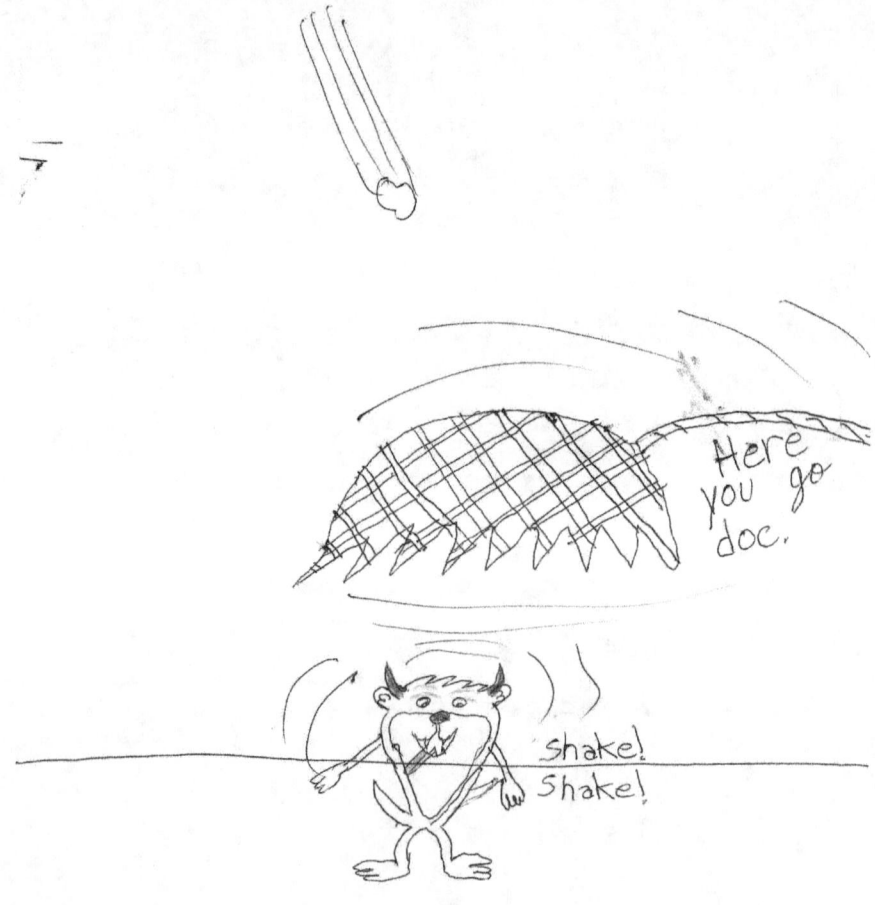

48

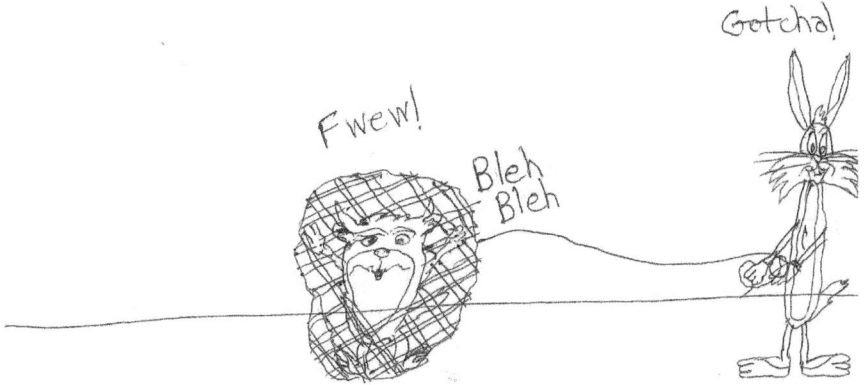

49

Later

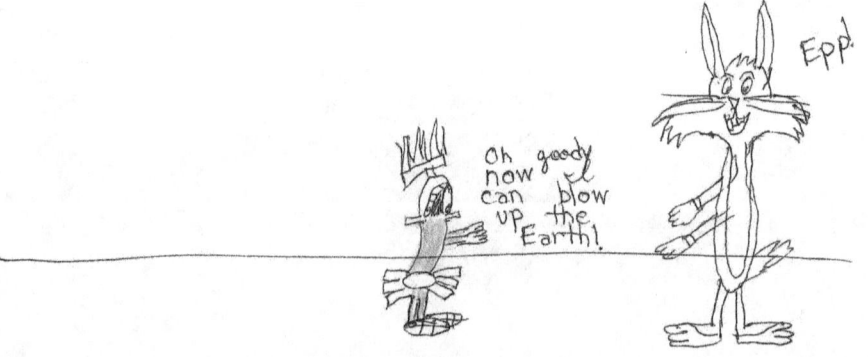

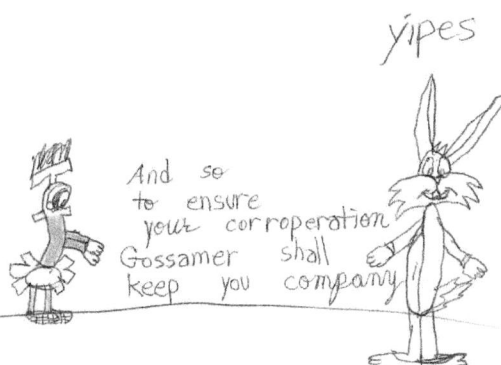

Gossamer get him! zip!

52

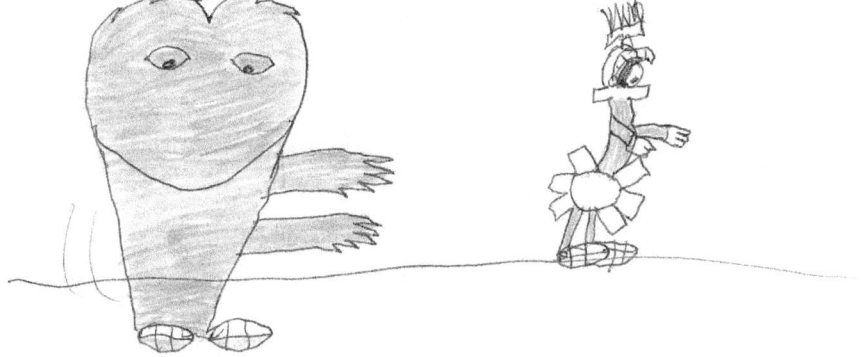

53

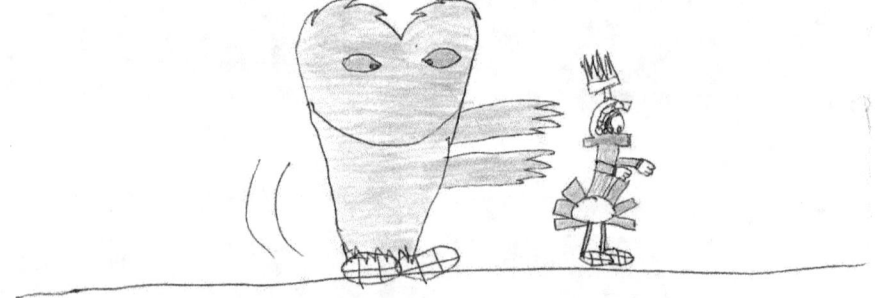

54

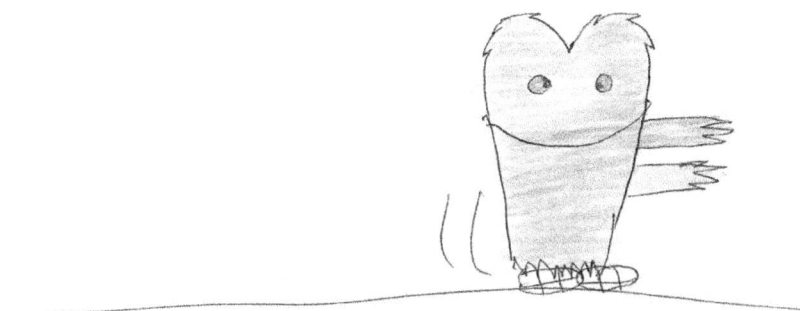

Later 5$

58

61

Bye doc!

Oh no uhga ugh

64

66
completed 5-19-2010

Yeowh!

well that's that! so long see you in St. Louis!

Gossamer please don't do ~~that!~~

Ugh!

The end

The next cartoon is a Durge and Shaak Ti cartoon.

The idea just kind of arrived in my head to do one.

It's based on Shaak Ti Stories which was a project that was attempted.

Enjoy.

Shaak Ti and Durge in... To catch a Jedi

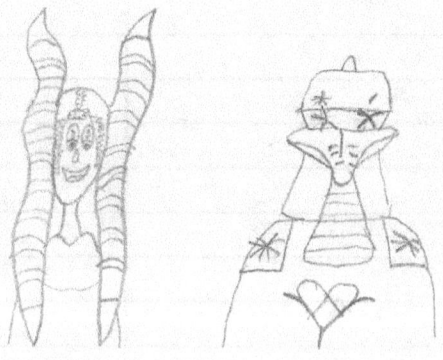

2012

Later... 6

rata - tata

Later... 9

Voomph!

Voom!

10

Oh no! whirl

zoomph!

yeow!

This cartoon is considered by me to be some of the finest animation drawling I've done in years.

Now then it's on to the next cartoon

This one was made quite recently.

It features Cool Cat and Spooky, they were Seven Arts characters and it's a shame they fell apart.

I have plans to revive the series on youtube.

Cool Cat
and Spooky
in...

Catch as Ghosts
Can

Hewo!

2011

Cool Cat

Page 1

Later...

Later still

This place is amazing!

Tip-Top

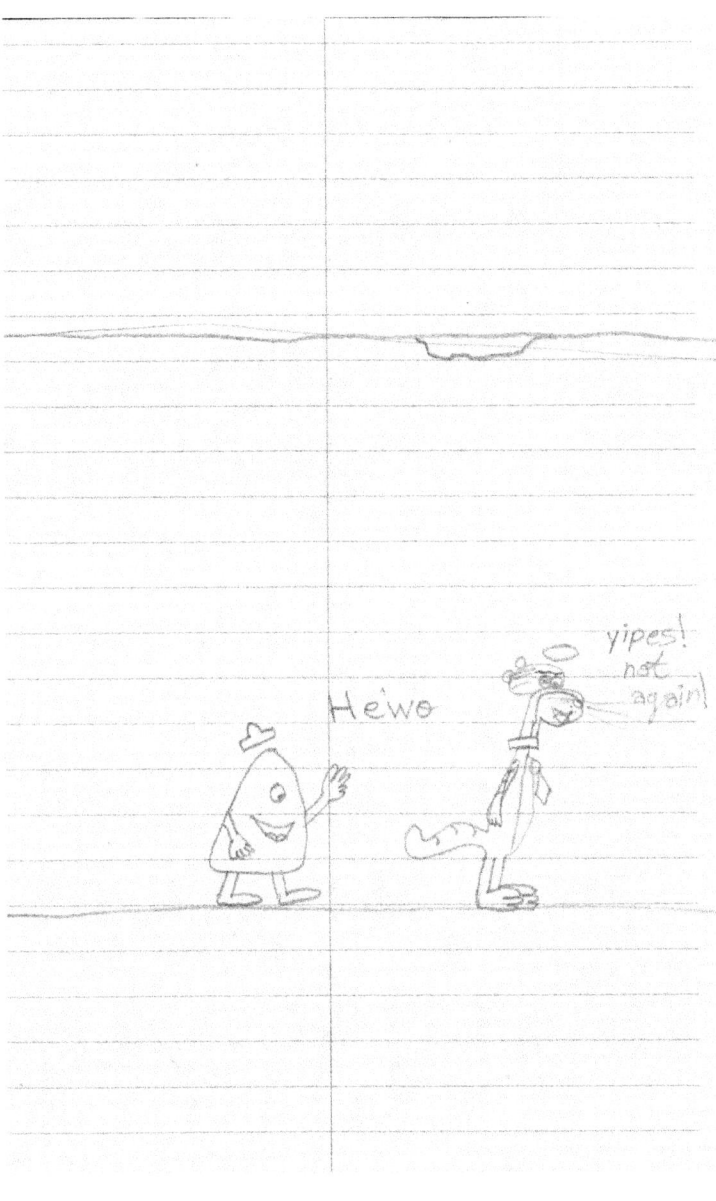

swooh!

bople Hewo There!

Later still...

Hewo!

The end

It takes a cat to be a scaredy cat.

This Next cartoon was only two pages for a period of ten years and then I picked back up the project. Enjoy.

It was an attempt to see Daffy and Wile E. together.

completed 2007 9-8
1996-2010 P. 1 Ducks must Fly
5-16

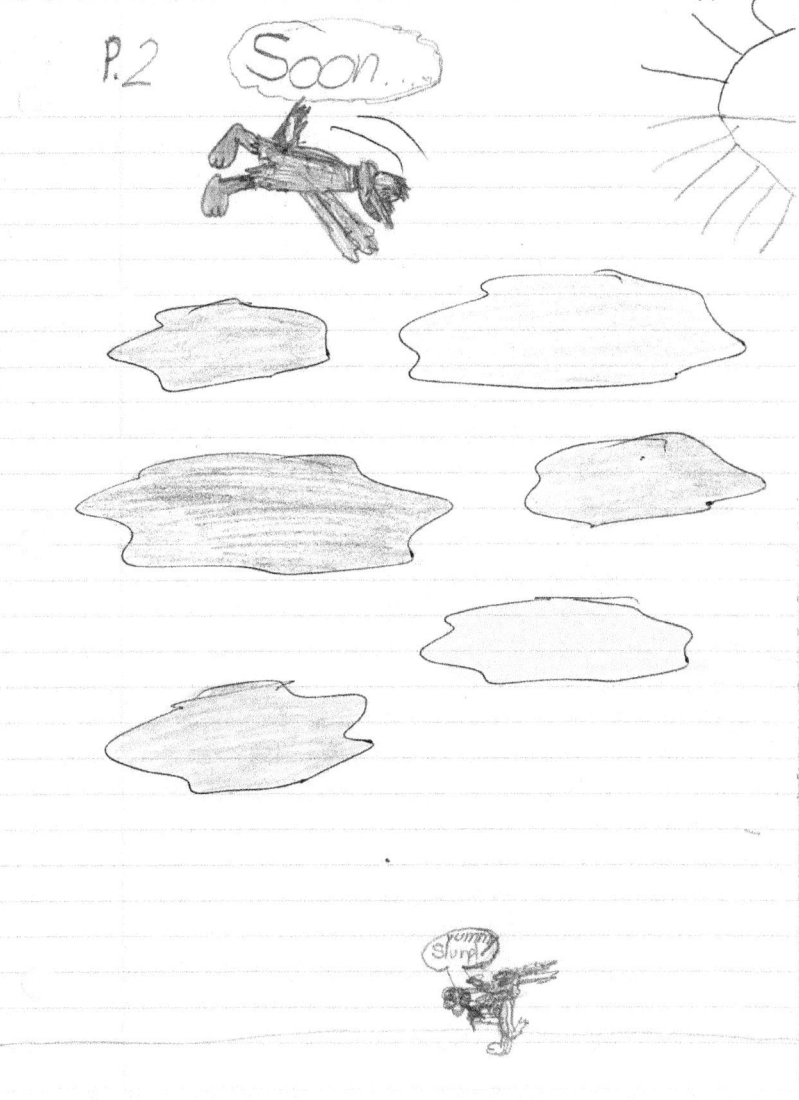

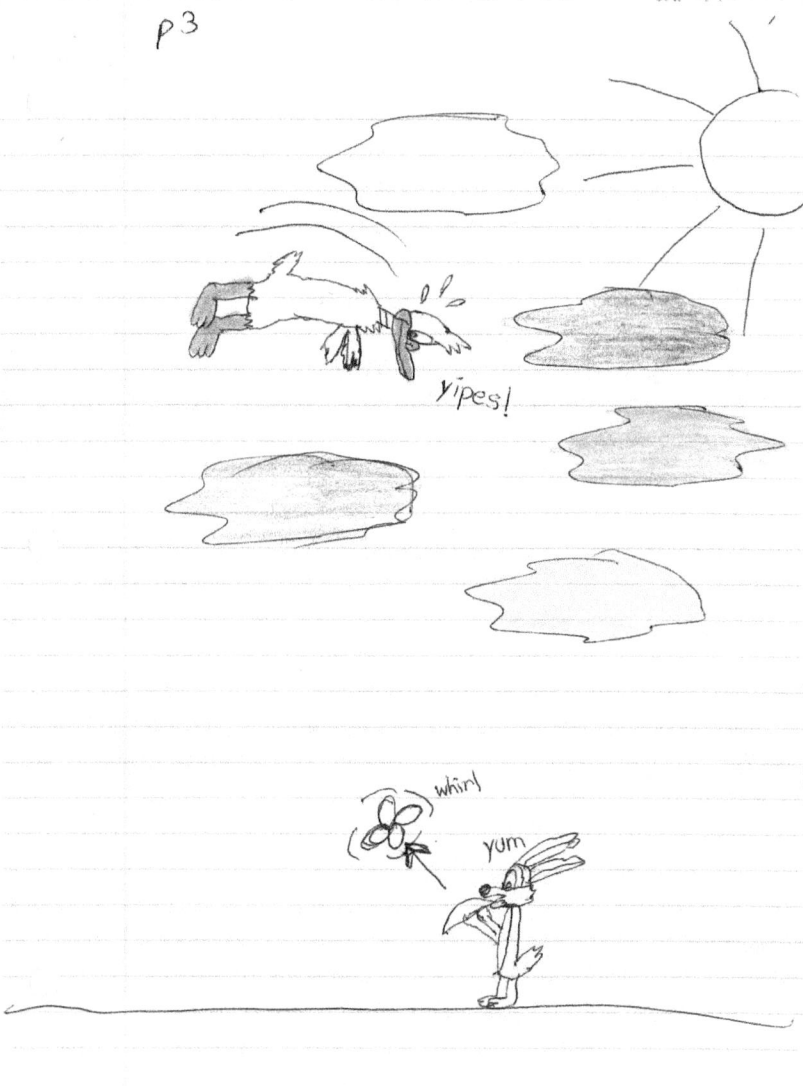

p 4

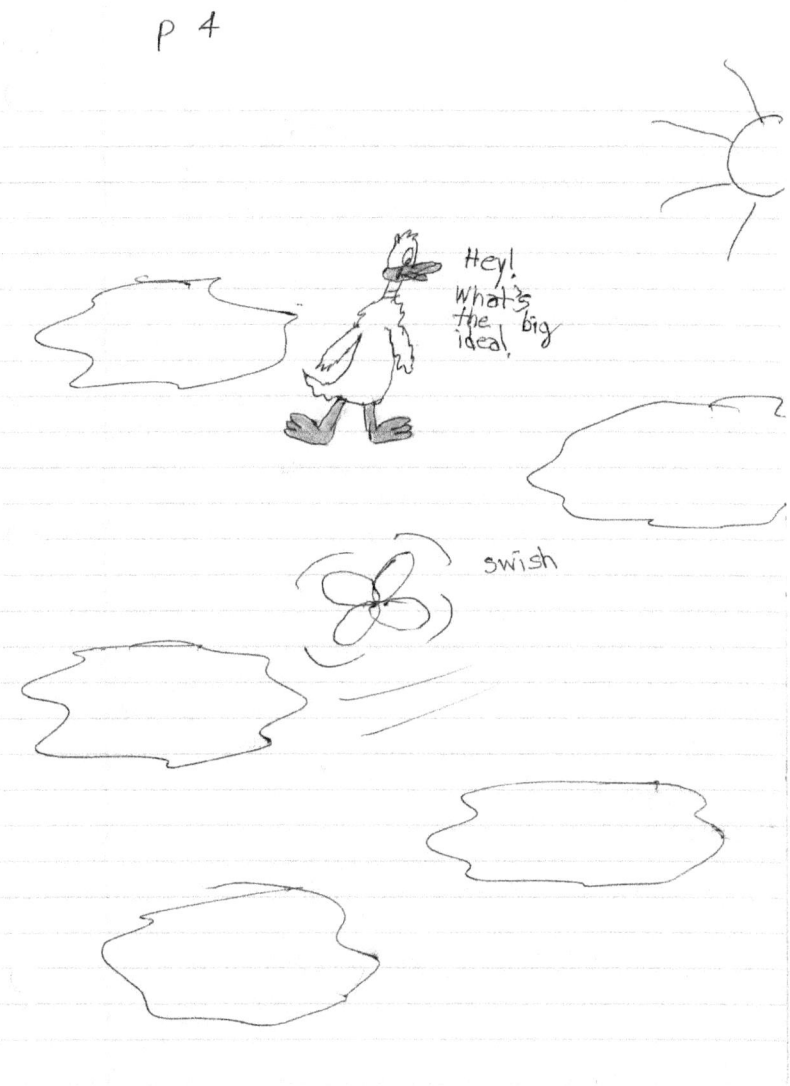

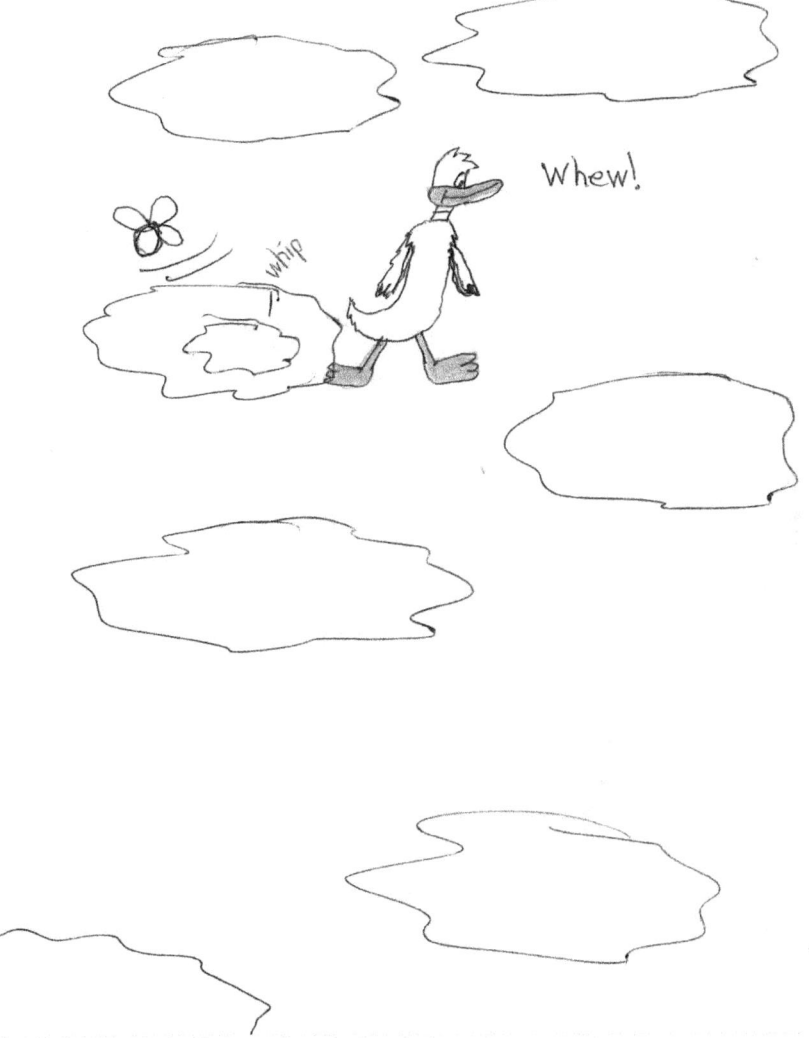

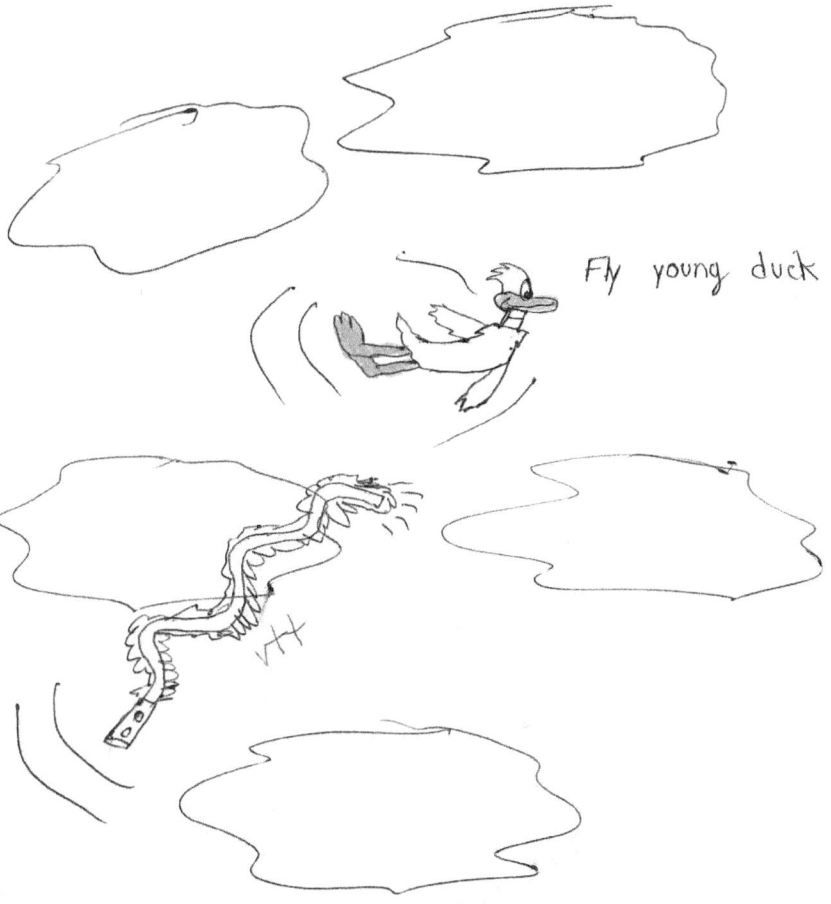

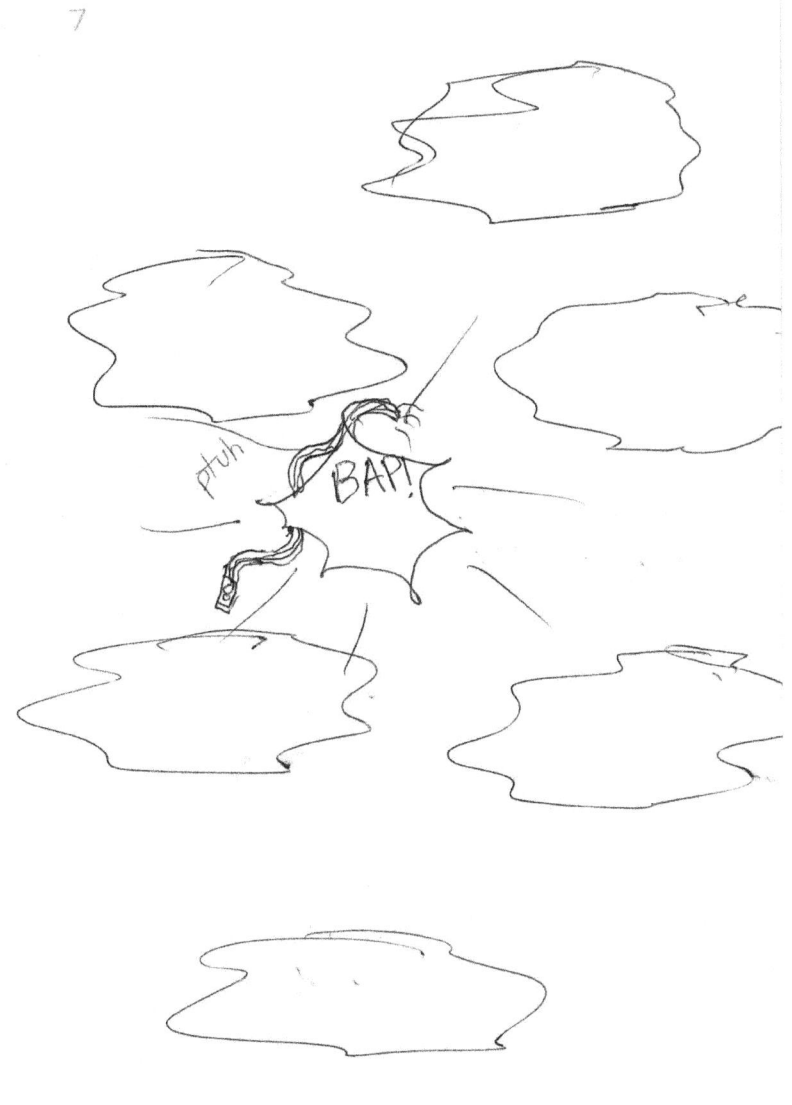

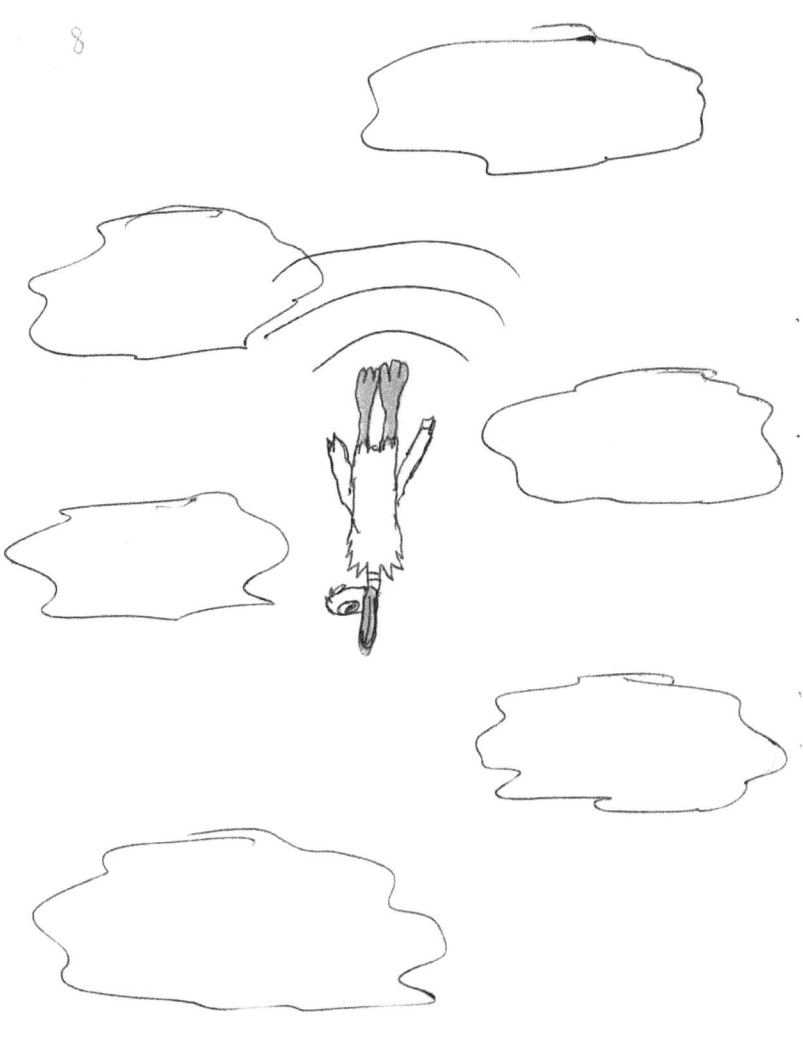

9

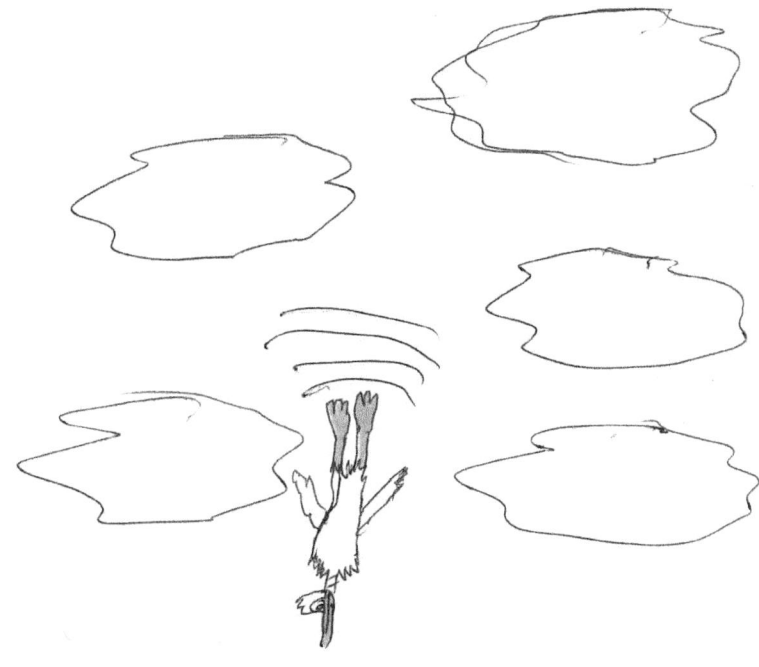

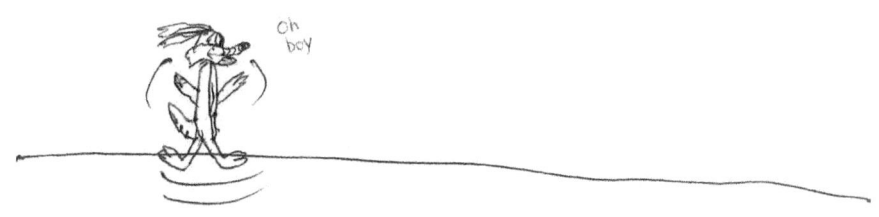

10

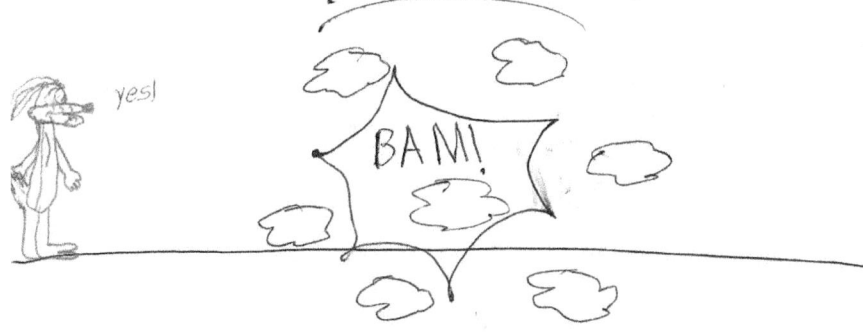

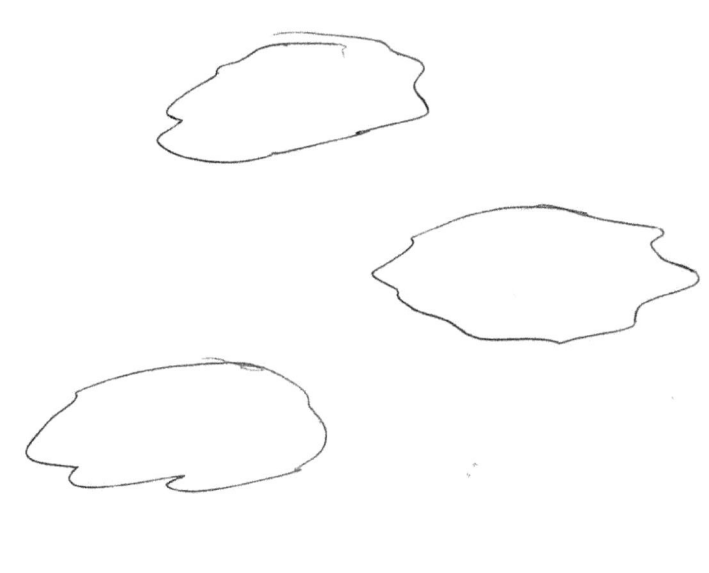

12.

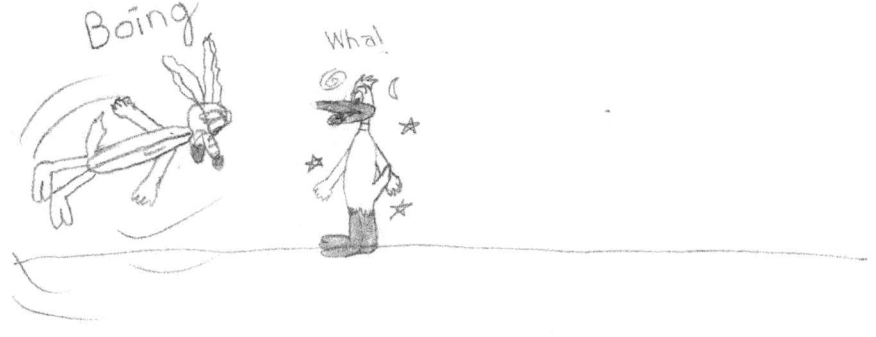

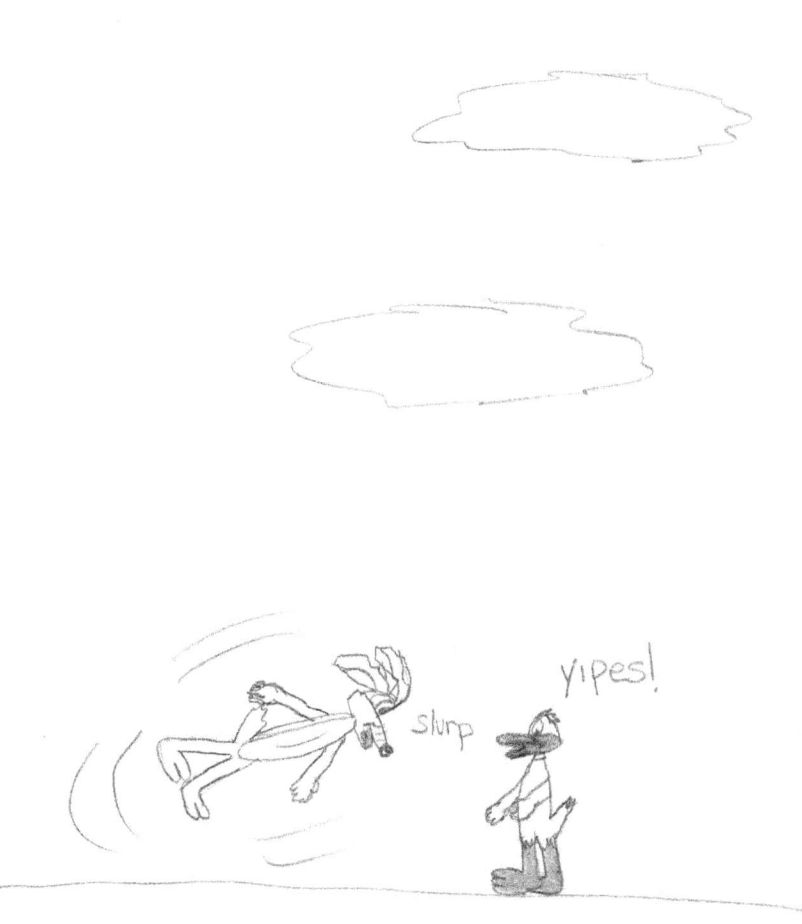

14

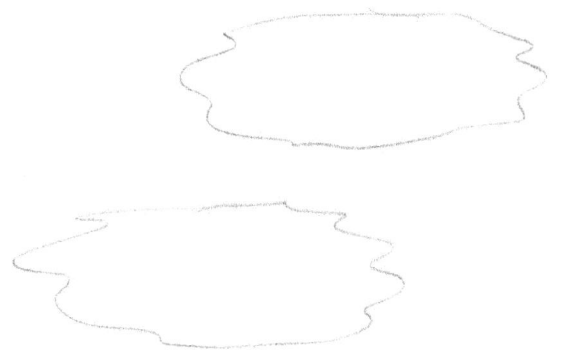

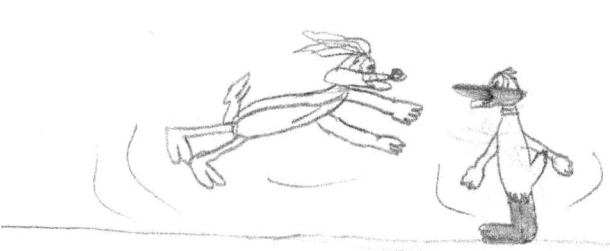

Later

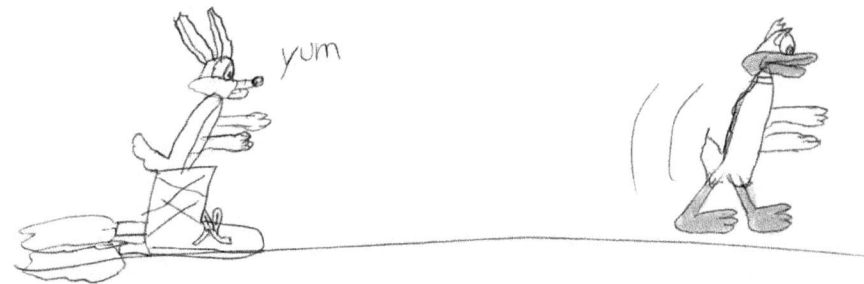

Later still

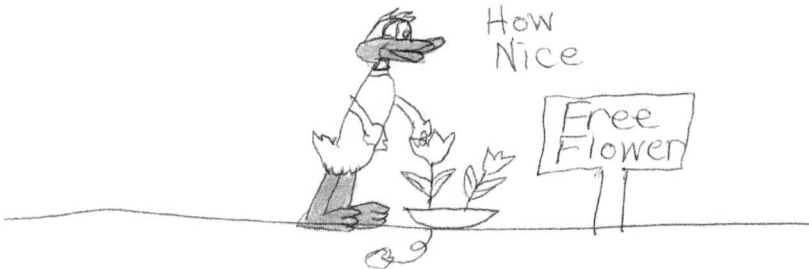

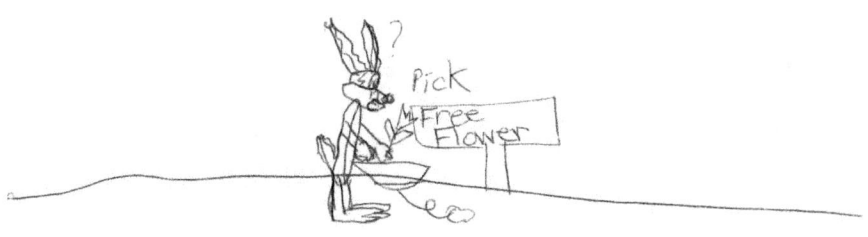

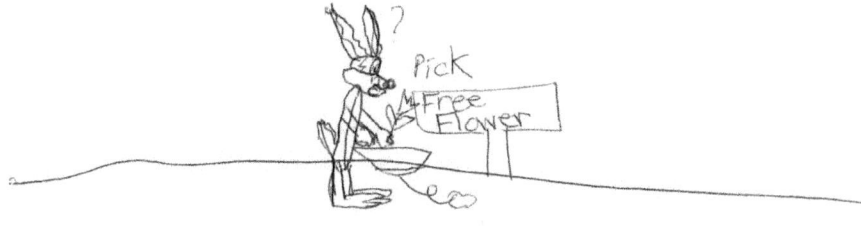

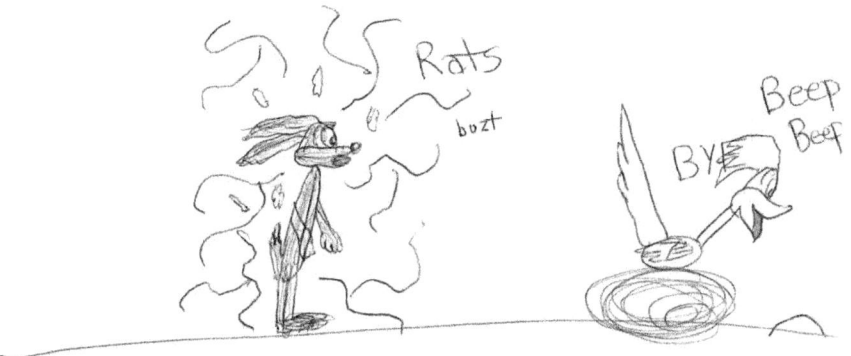

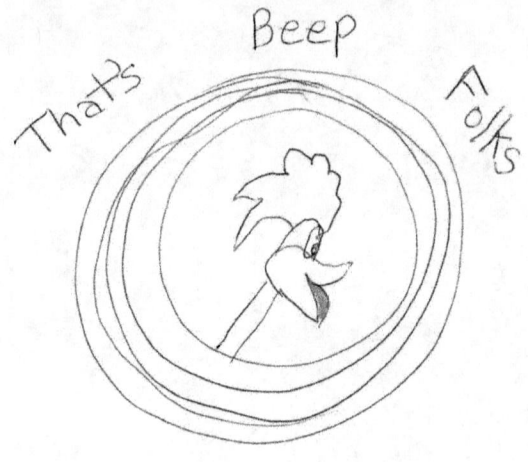

The next Cartoon I made based on the hopping snake in the Road Runner Death Valley Rally Snes game.

Squiggly The Blue Snake and Beep Beep in... What Comes Around Goes Around

Beep!

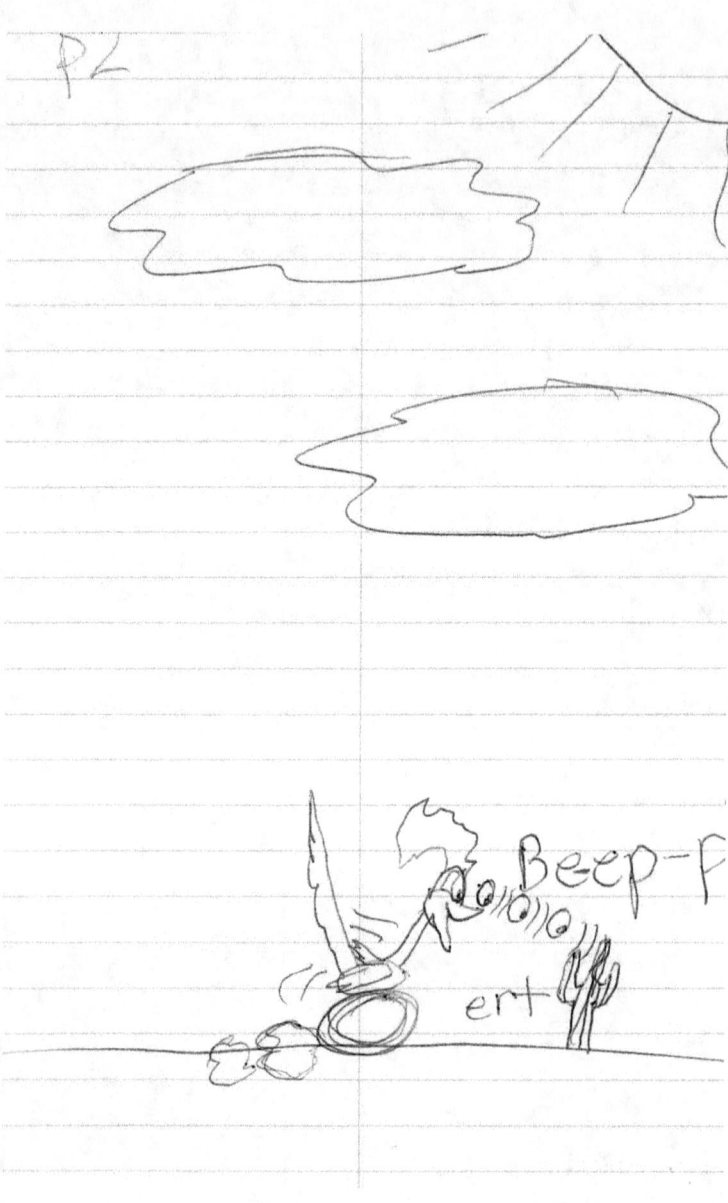

4.

10

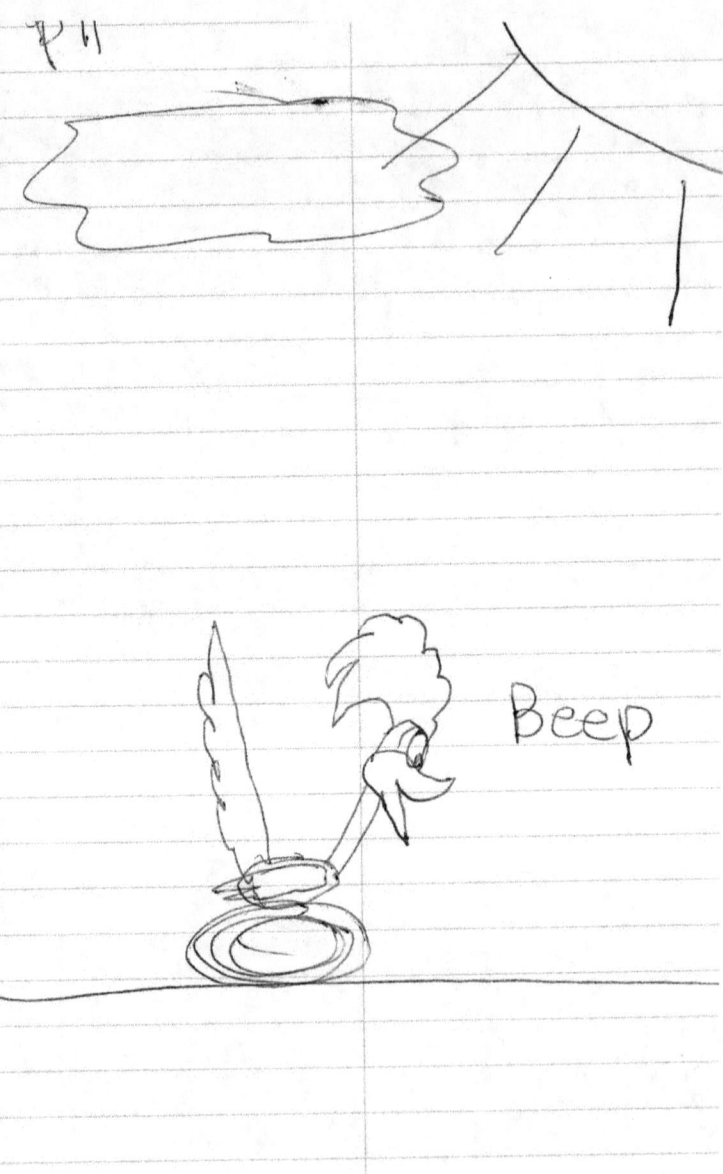

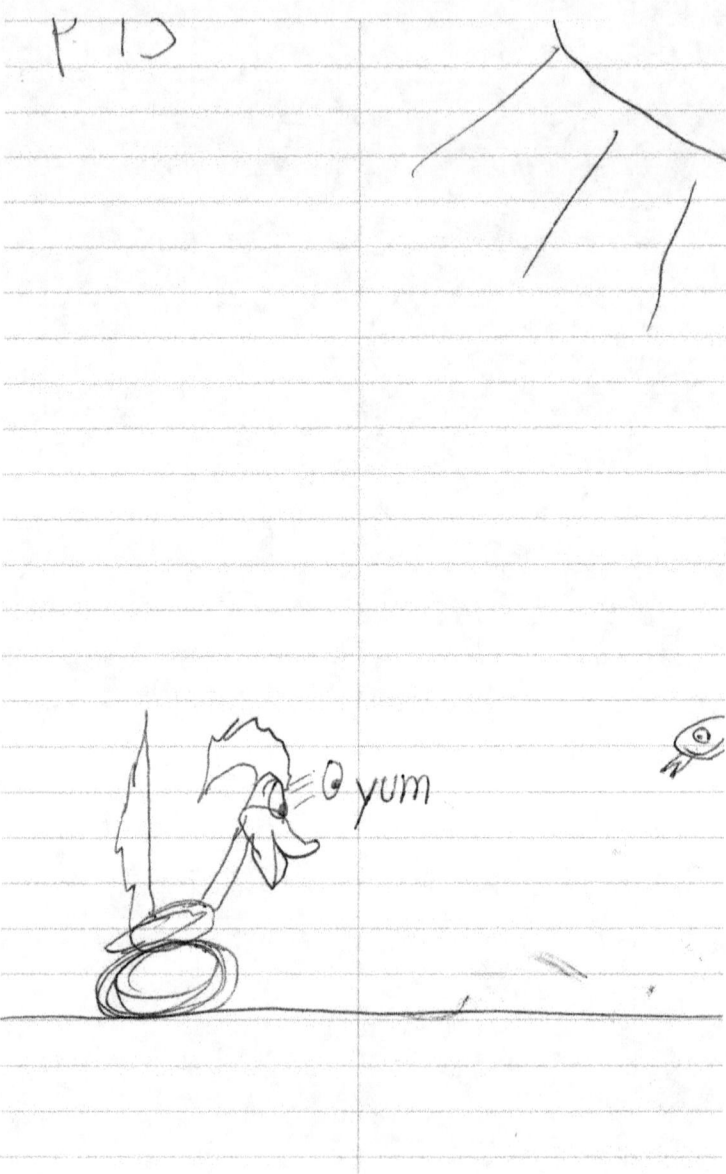

p 14

P 20

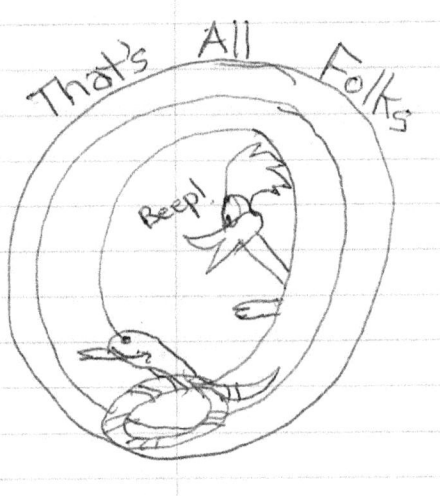

5-10-11

This next part is a remake of an idea I had called Flopsy Stories

It was short lived.

Flopsy and Friends

I'm bored

As you can see my cartoon had a Garfield base to it perhaps one day I'll revisit my pet Flopsy idea as a cartoon character.

Next up is Smiley the Worm a brand new character based on the worm from Foghorn Leghorn.

A tomato worm was the inspiration of Smiley, and I wanted a roadrunner and coyote base to it too.

Munchy the blue monster and Smiley the worm

I thought Smiley and Munchy were a good duo so I tried them again.

Smiley and Munchy

The next cartoon was just for fun.

created on
Dec. 19-06

"Welcome to McDarth's can el take your order please"

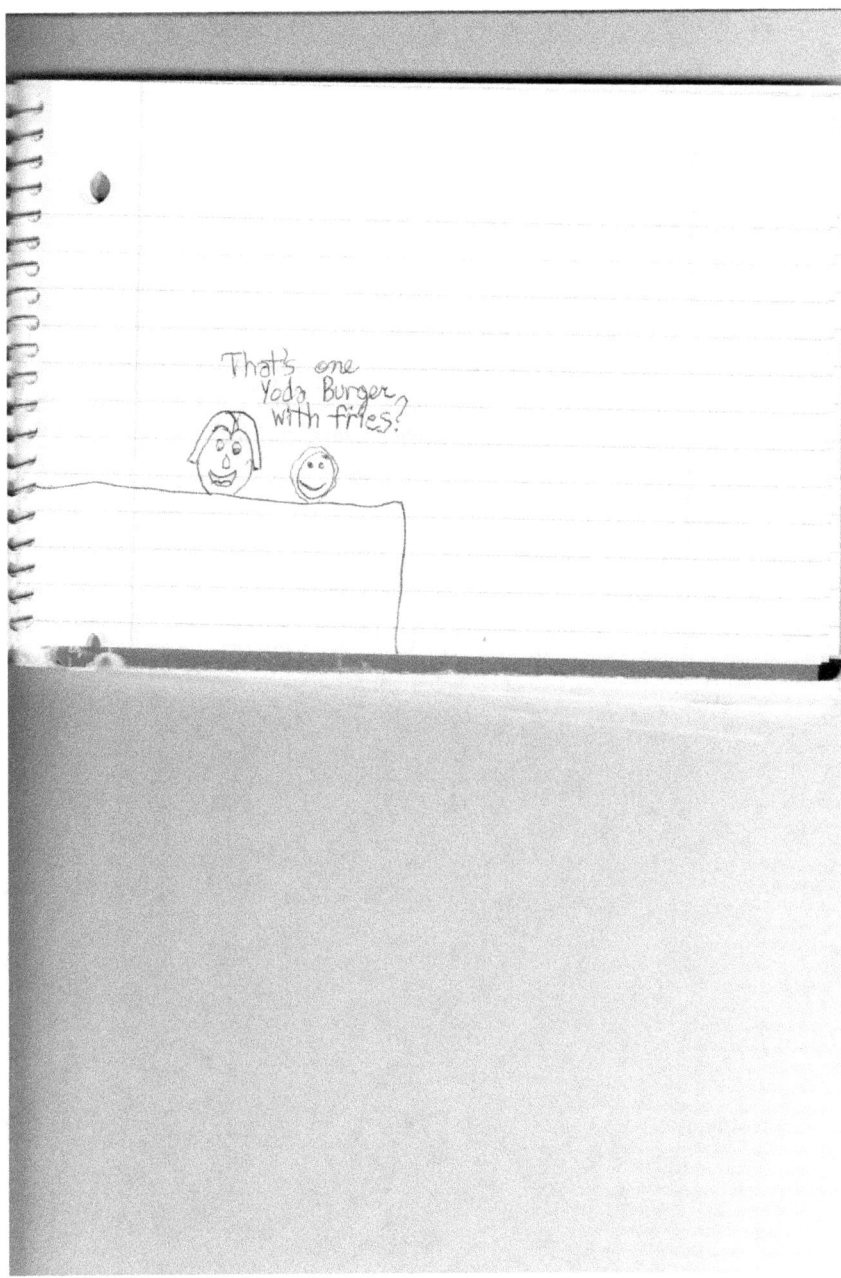

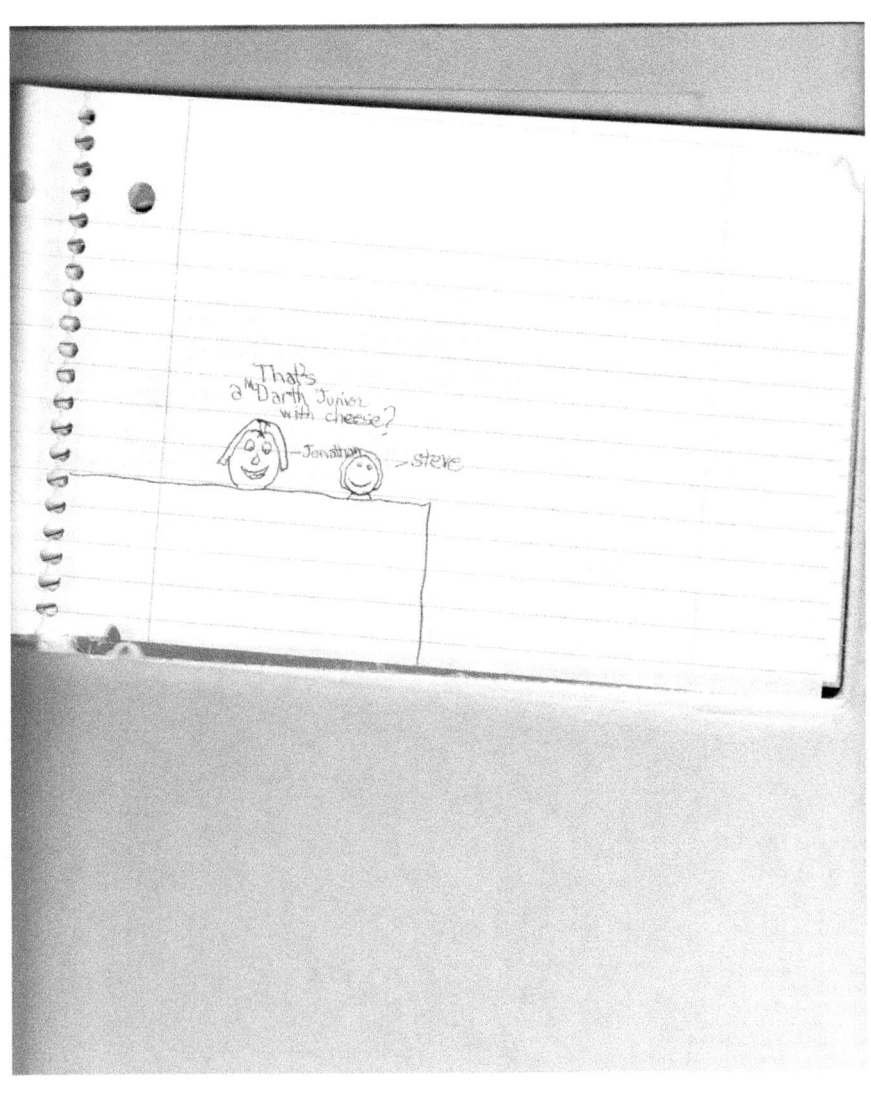

I hate to burst your bubble but we don't say the weird Mc around here.

—Mommie

Backyard Burgers

The end

Next up is Ali the Red Gater a new creation based off of George the Gater from Looney Tunes.

He appeared in at least three of the Original Looney Tunes.

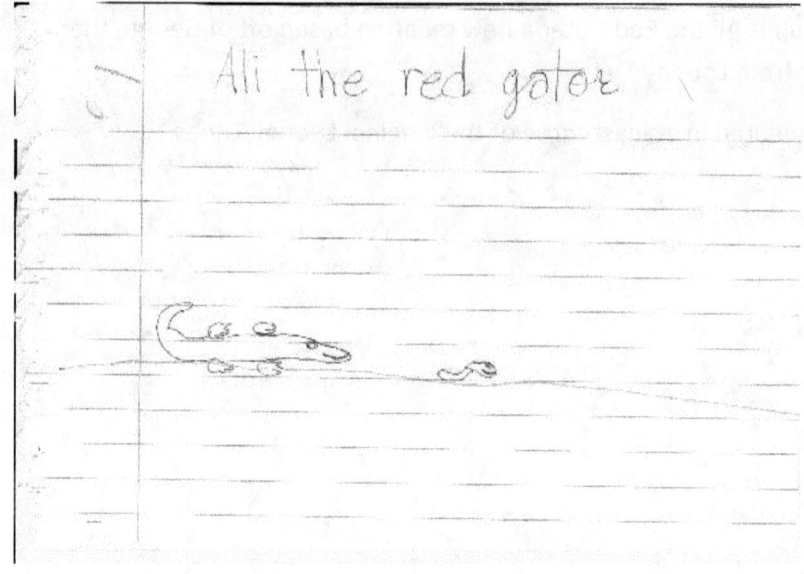

Ali the red gator

Well that's it for now, I hoped you enjoyed it.

Jonathan

www.ingramcontent.com/pod-product-compliance
Lightning Source LLC
Chambersburg PA
CBHW051622170526
45167CB00001B/29